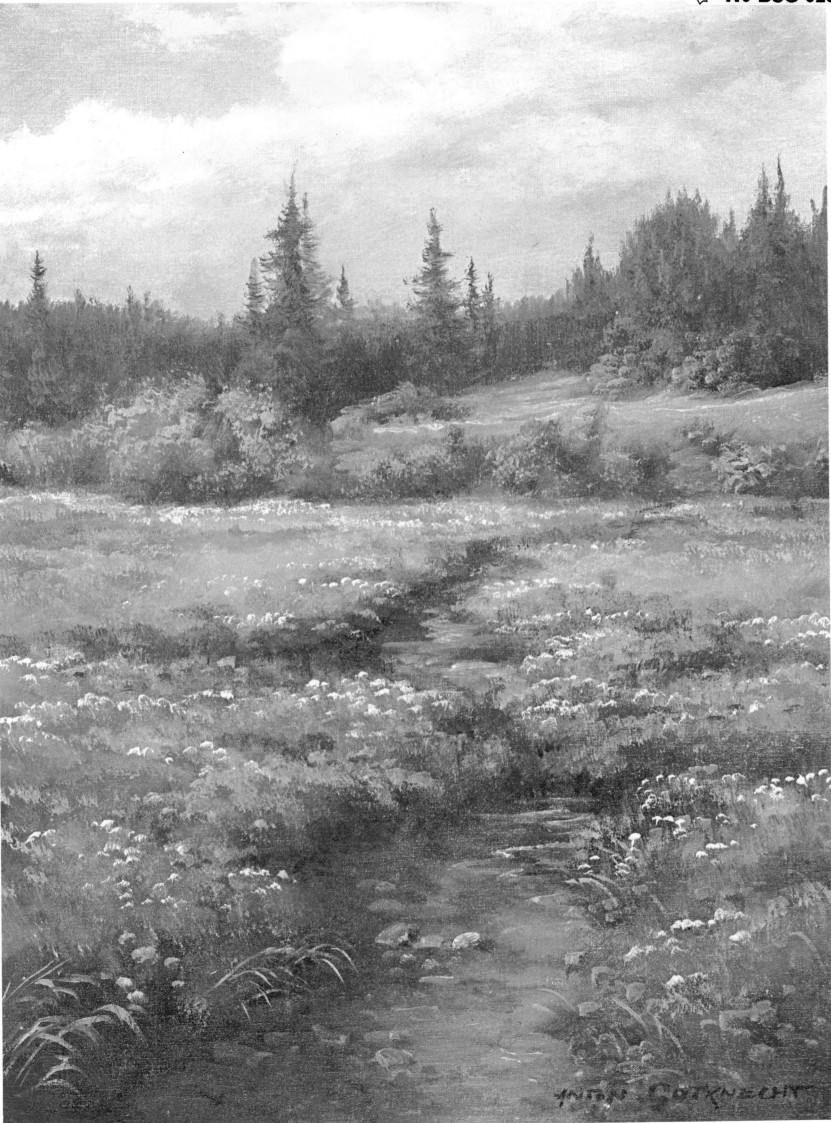

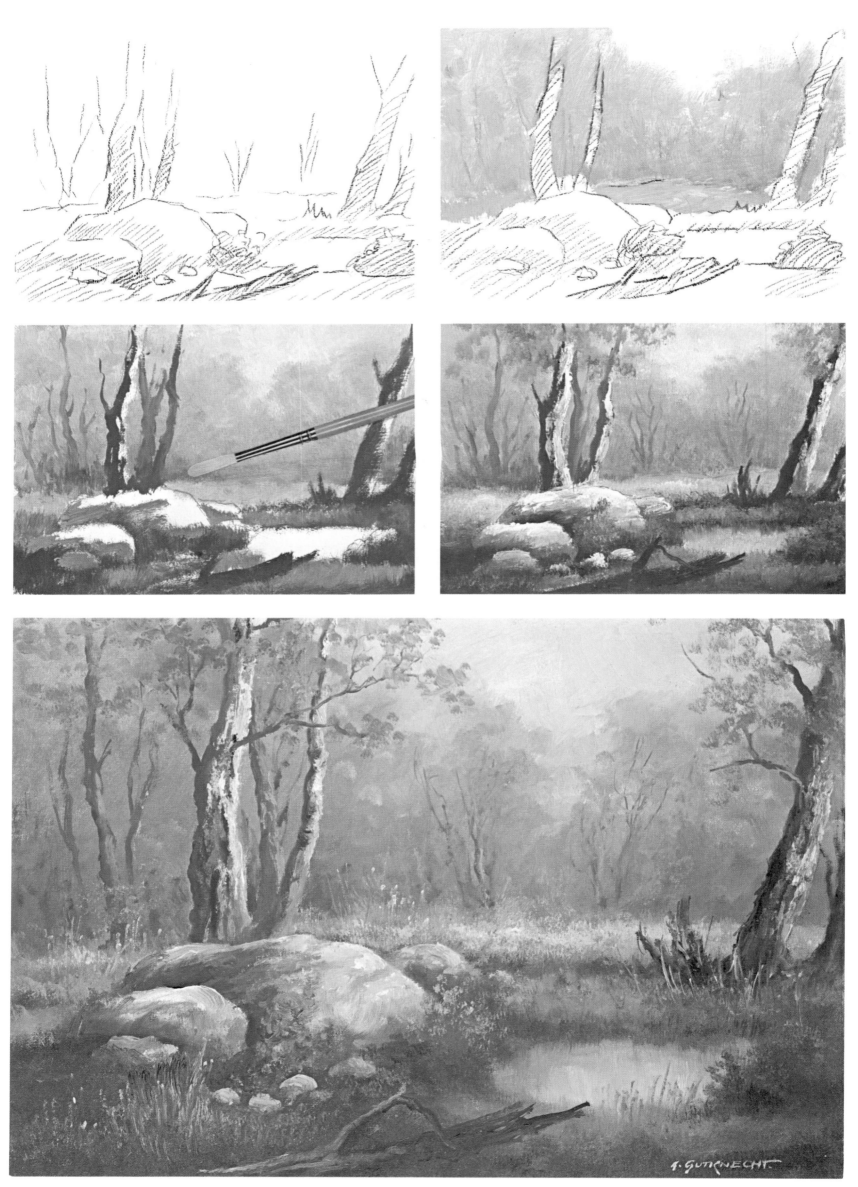

In The Morning Mist

The purpose of an impressionist painting is to show the first "impression"; that means to leave out all details that are not important, especially on the background. A few striking ones are left in the foreground for emphasis.

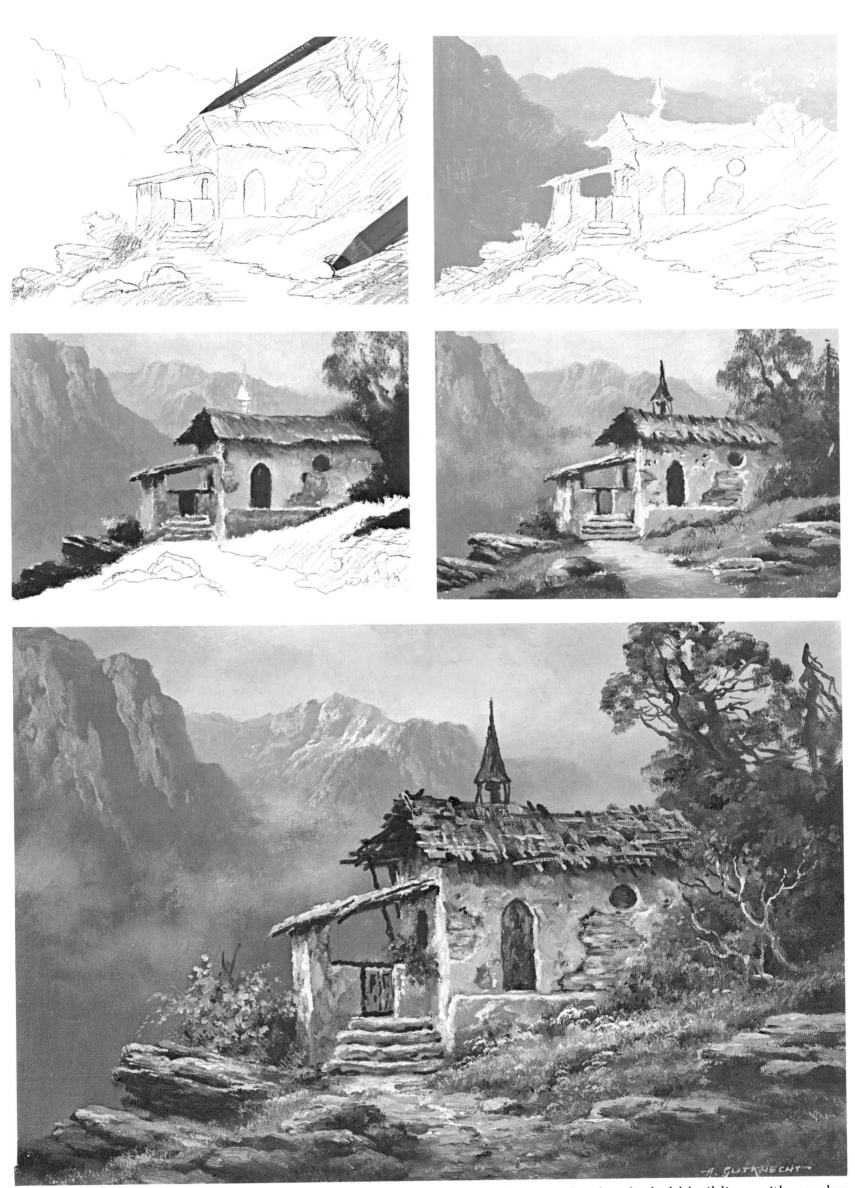

This little old church is in the Austrian Alps near Lake Gosau. Nowadays it is hard to find old buildings with wooden roofs. The sunlit wall and the dark shadows and tree make a good contrast to the blue mountains. The colors for the mountains are mainly Cobalt Blue and Red (Cadmium Red Light and Crimson). Try to balance colors on a piece of waste canvas, the correct amount of each, mixed with White of course. Put in the clouds later.

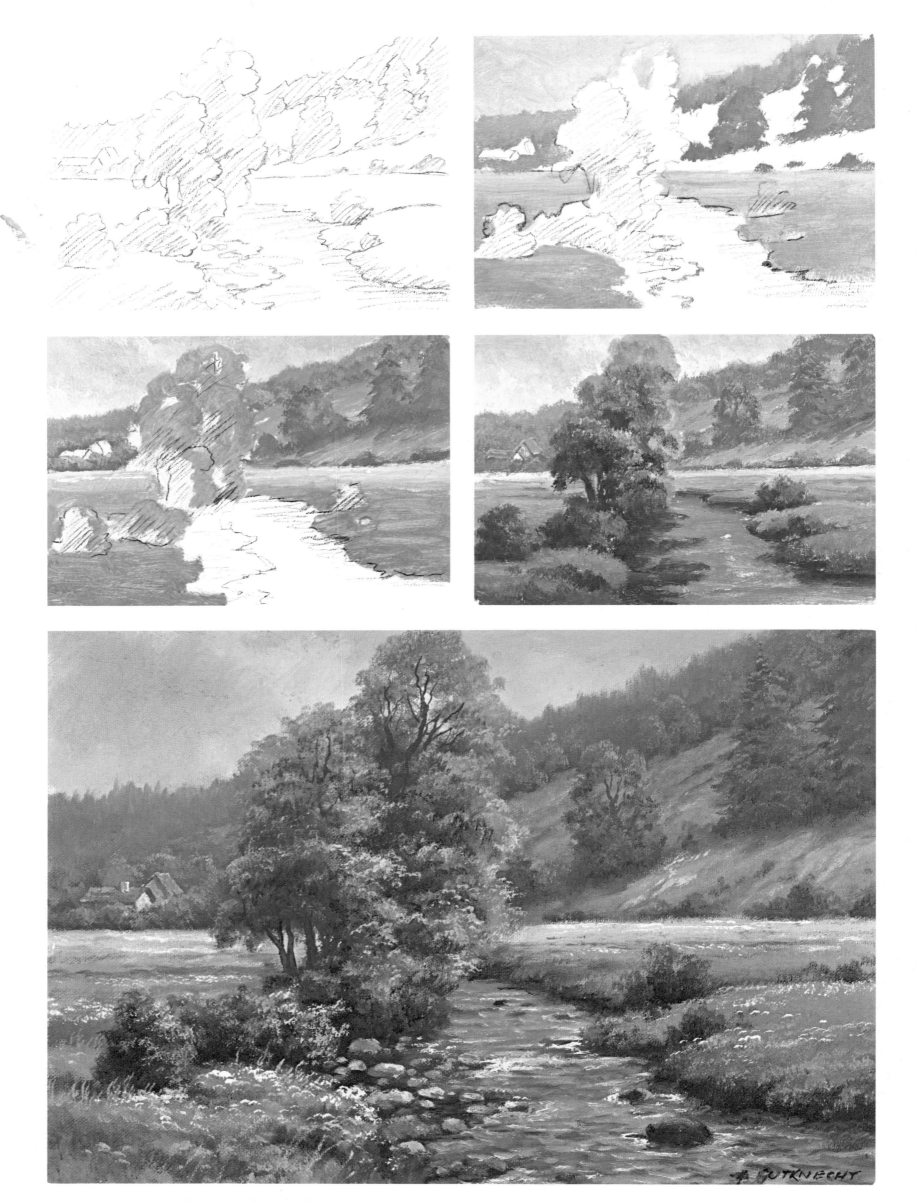

This blooming meadow is in the Black Forest, West Germany. The strong colors of the trees and rocks in the foreground make a contrast to the pale colors of the more distant slopes and forest. The effect of atmospheric distance is obtained by adding a little White with Cobalt Blue to all the colors used in the background.

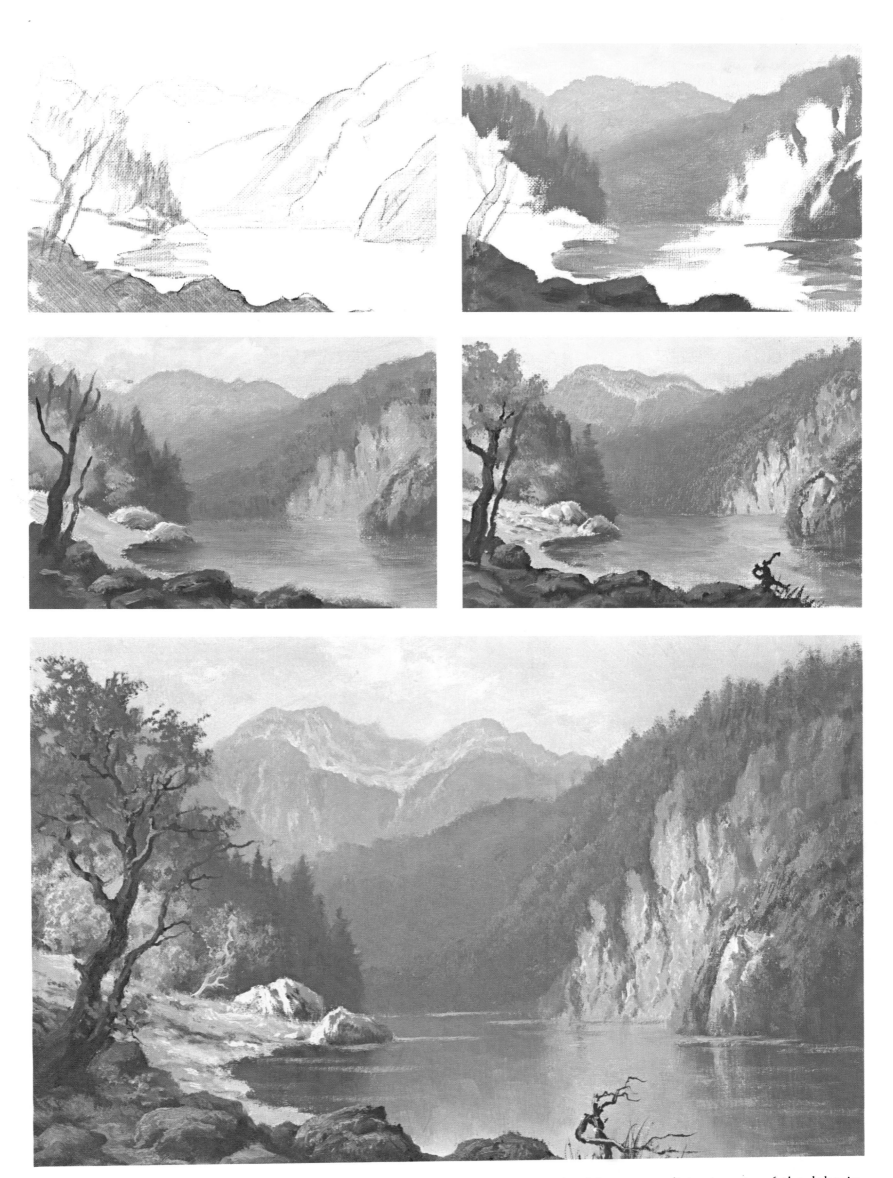

The sunlit parts—the shore, left, and rock face make a good contrast to the blue more distant parts of the lake in shadow. The basic colors of the mountains in the background are Cobalt Blue, White and a little Red. For the light parts, White and Orange with a small amount of Red. The forest is Cobalt Blue and a little Paris Blue with less White than above and a small amount of Red. The trees consist of the above mountain colors plus White and Orange (or Red and a little Yellow for a change).

5

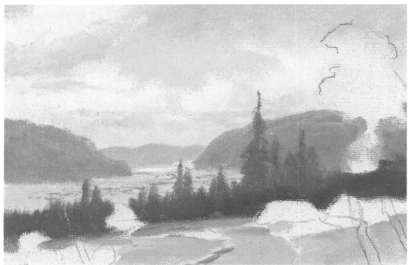
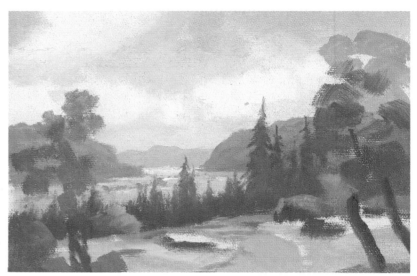
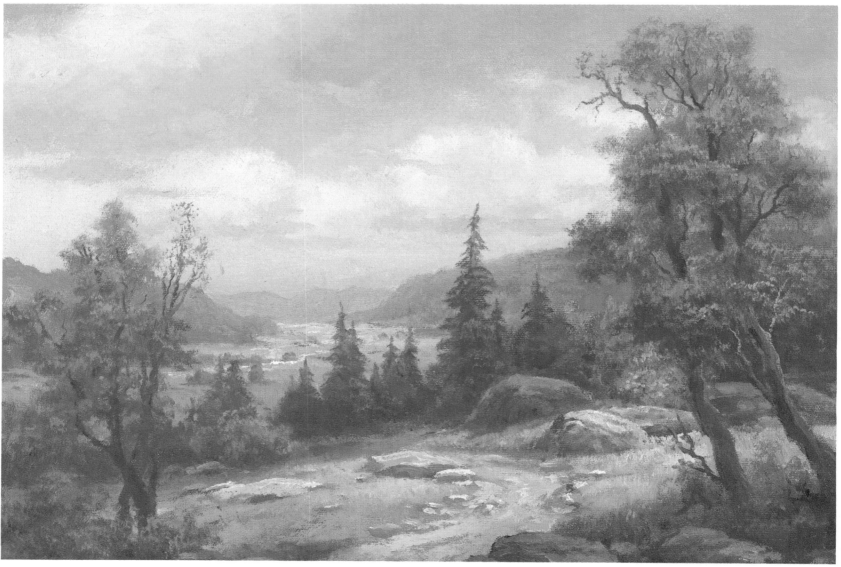

Autumn In The Hills

Notice how the foreground shadows contrast nicely with the warm fall colors. As your eye is drawn down the trail, you become curious as to where it leads.

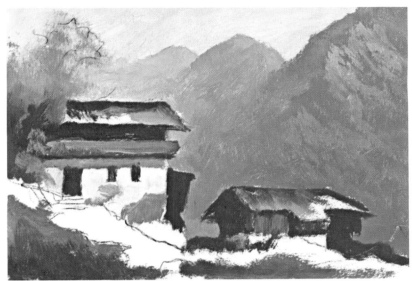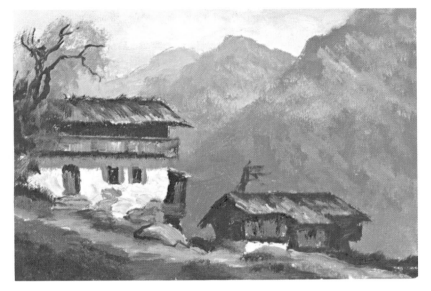

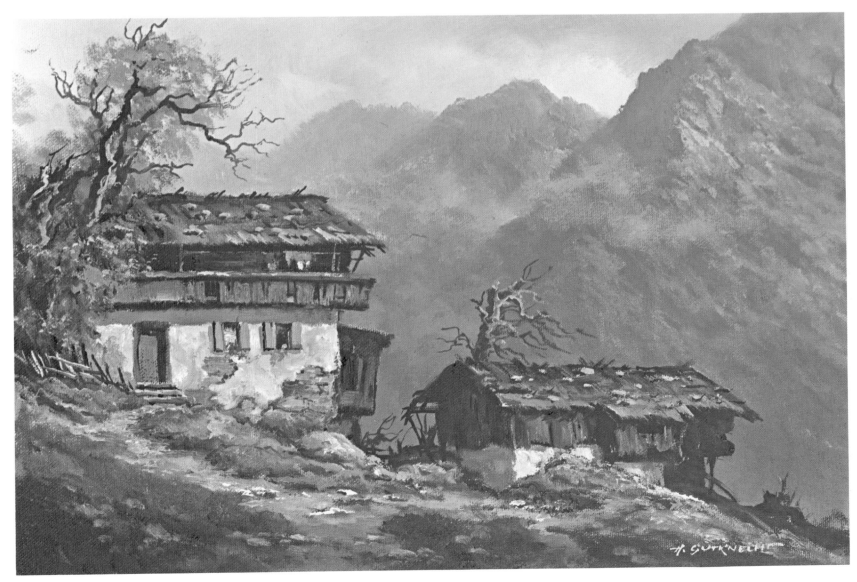

These old houses are in Tyrol, Austria. You are lucky if you discover some of these relics of older days.

An old mill sits in front of this house situated in the countryside not far away from the Rhine River, West Germany, my home country. I love the old romantic places. Only a few of them are left now, in Europe.

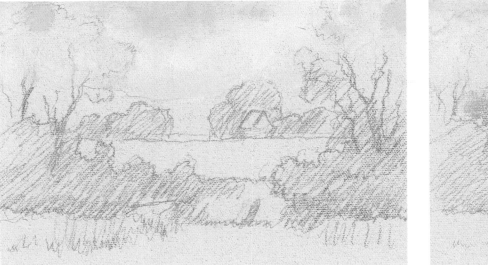

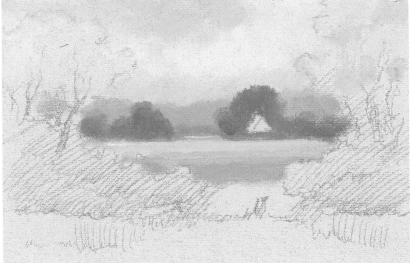

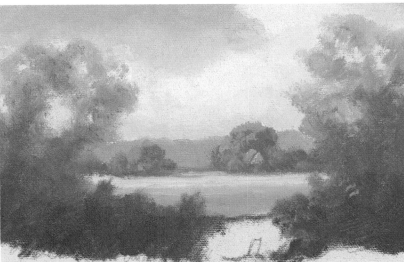

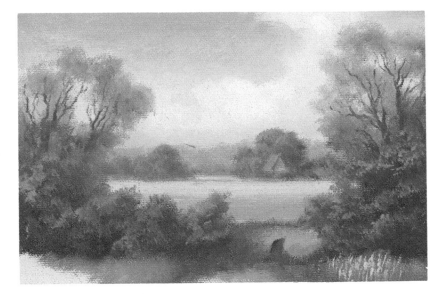

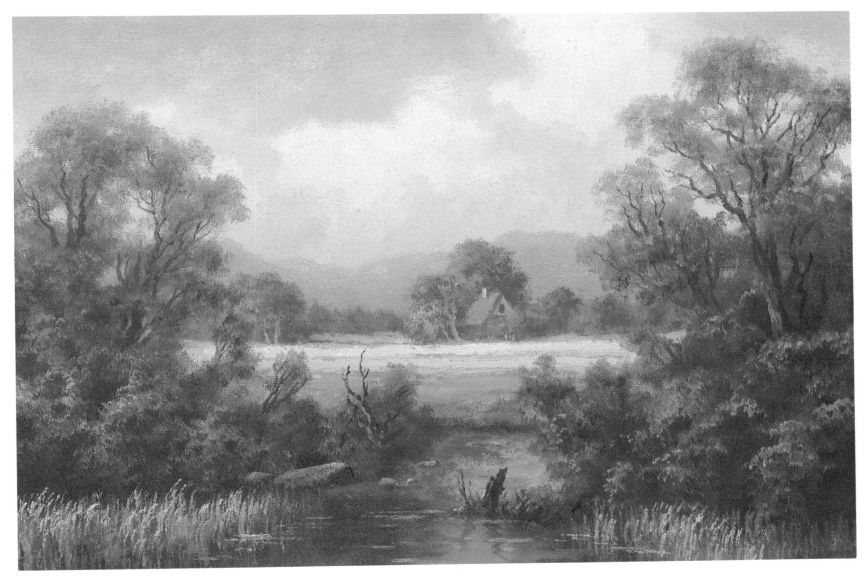

Remote Cottage

The focal point of this painting is the cottage. The eye is drawn to it because of the highlighting in the surrounding field.

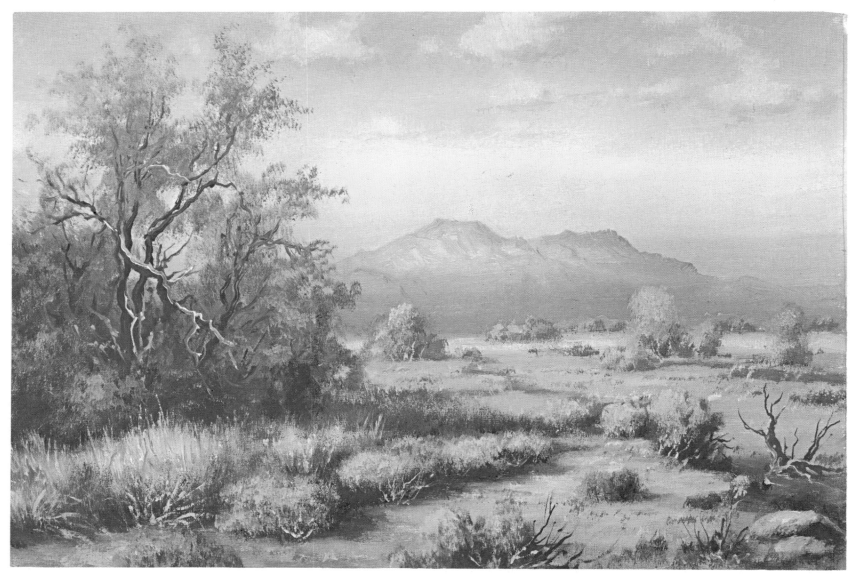

Later In
The Day

The desert always holds a great attraction for me. It brings me relaxation and meditation.

10

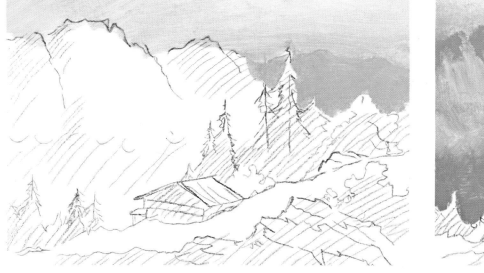

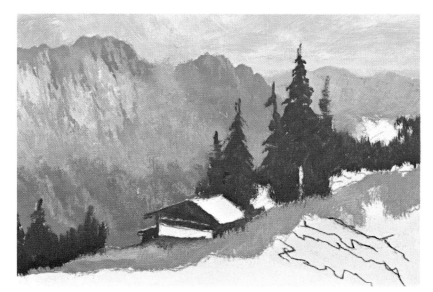

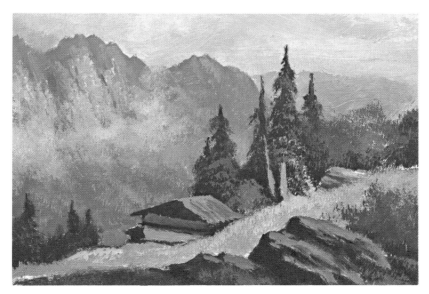

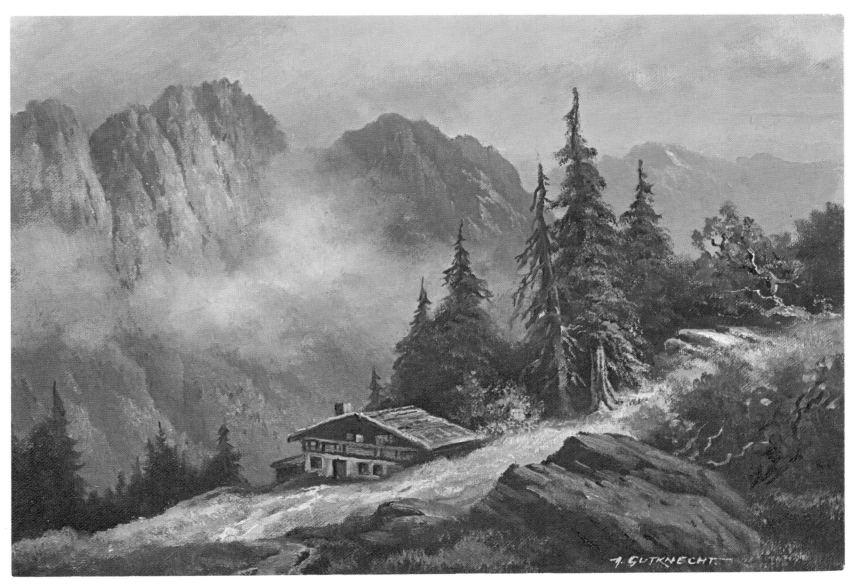

This is a scene in Grodnertal, Austria, in the Alps. The clouds are soft in front of the mountains. If you are not satisfied with the softness of the clouds, let them dry and wipe a little of the color over them with your fingertip (White and very little Orange). For a more shady effect, add a very little Cobalt Blue.

11

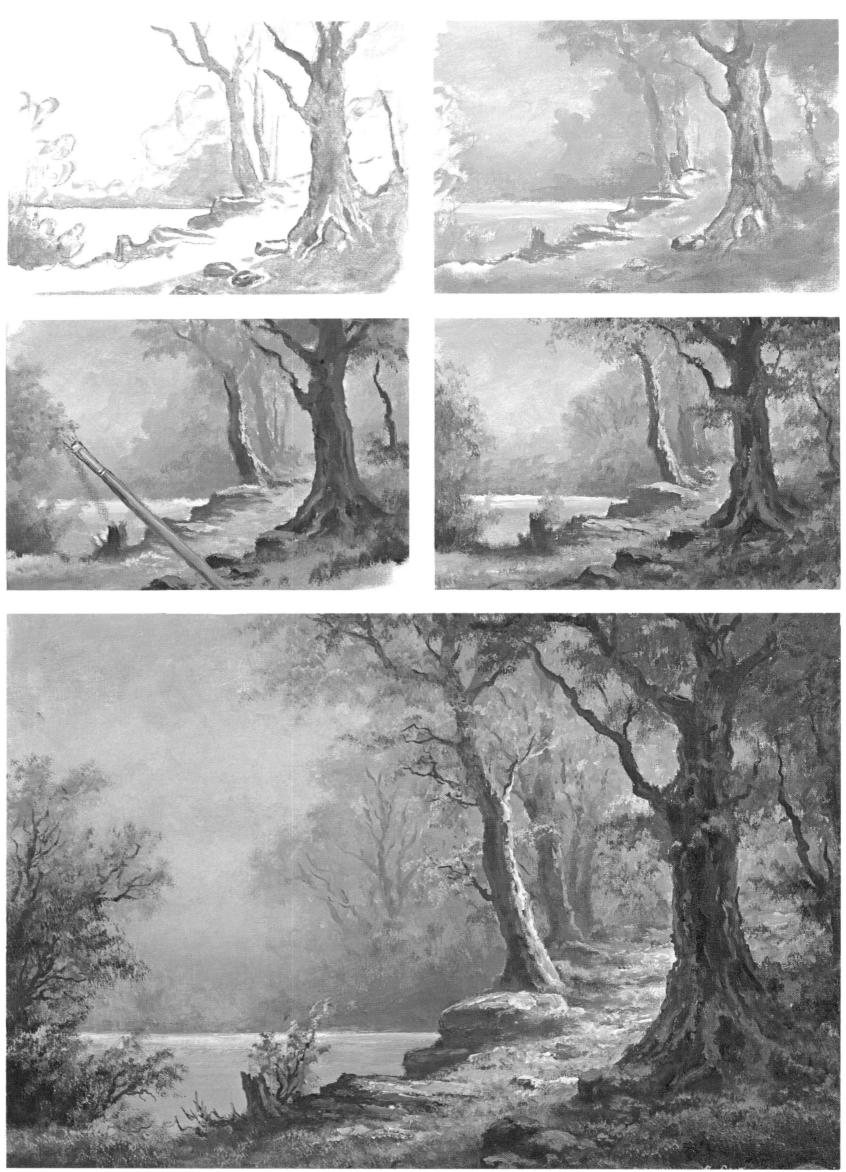

Path By
The Lake

An atmospheric mood is in this painting. Only the nearest foreground is in deep colors. The more it recedes, the more it fades in the misty atmosphere.

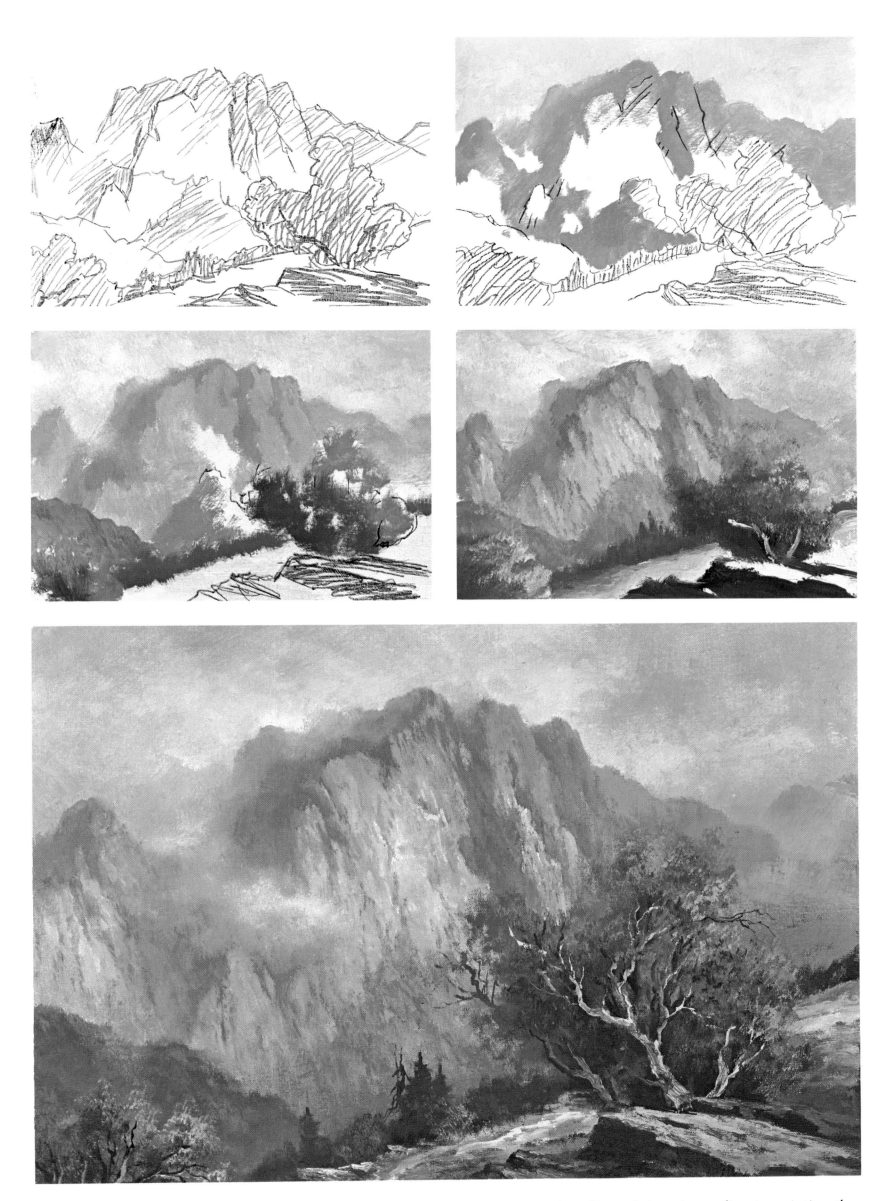

These are foggy clouds around the rocks. Here as on the preceding page, the effect of the picture lies in painting the atmosphere. This means putting deeper colors in the near foreground and softer colors in the more distant mountains until all colors fade into the sky.

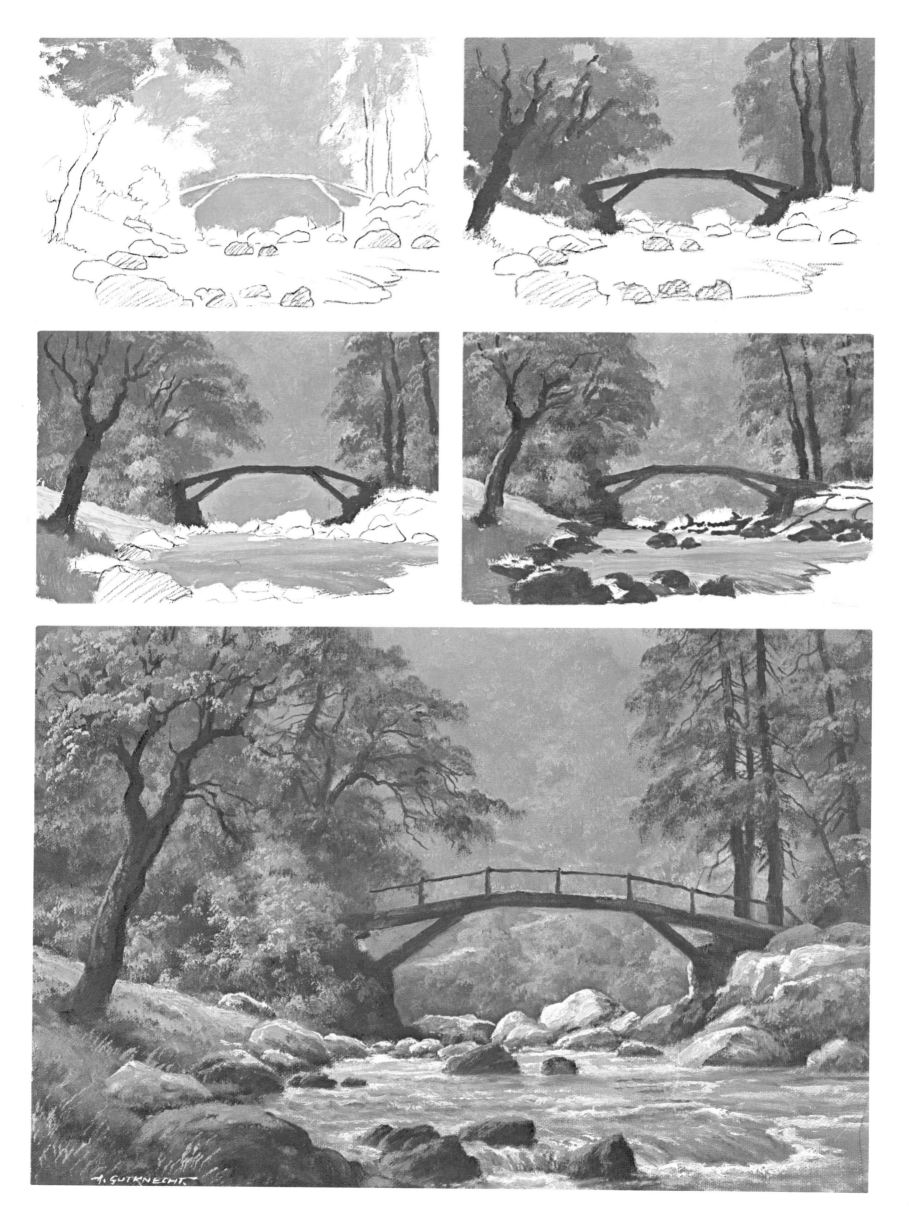

This bridge is over the Bode River in the Harz Mountains of West Germany. Here, the sun in the foreground shining on the banks, bushes, rocks and water form a contrast to the trees behind in the shade, the dark bridge and the blue of the atmospheric background.

14

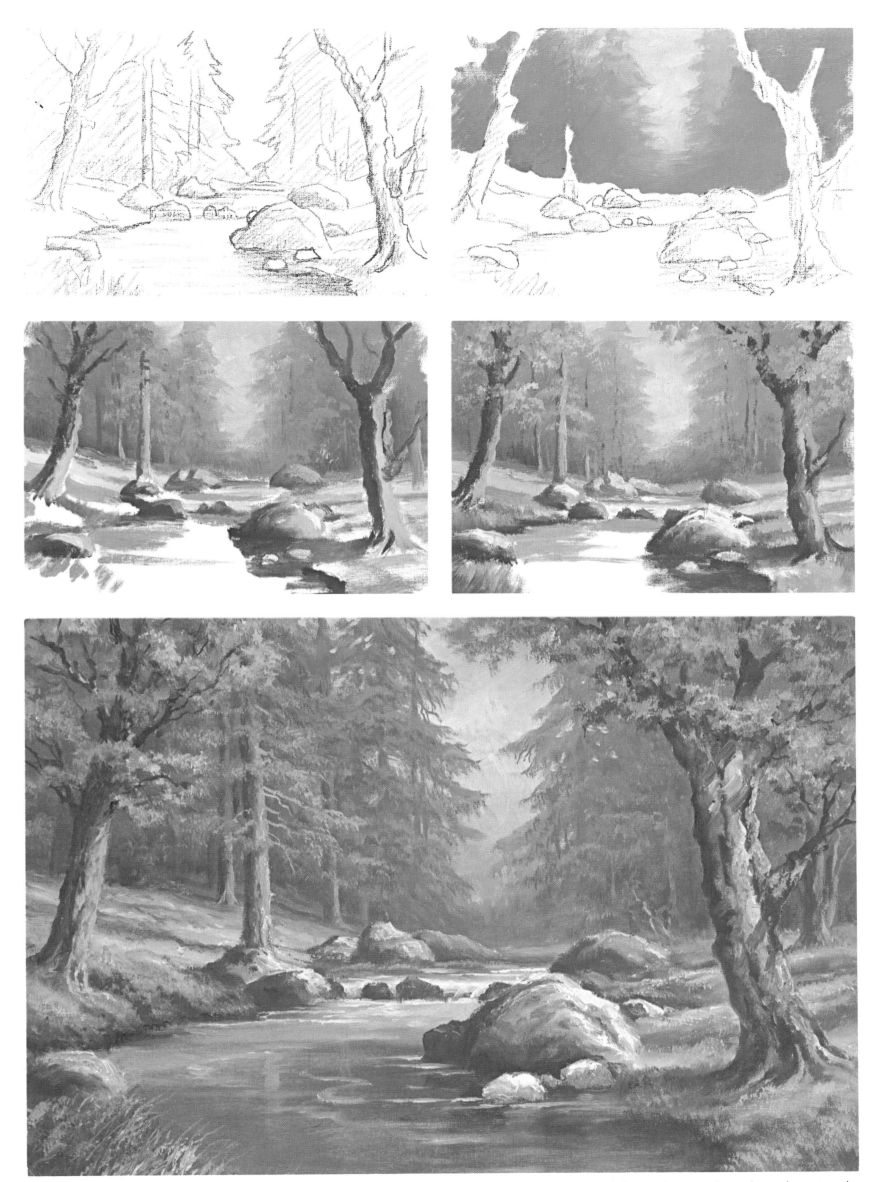

This scene is also in the Harz Mountains. How beautiful and refreshing it is to hike along the creek and study nature's palette in the fall season as well as around the year! Nature is the best teacher. Always have a little sketchbook with you when taking a walk. You can paint from your pencil sketches at home. It is much easier than you think. Practice will convince you; it will be fun to paint.

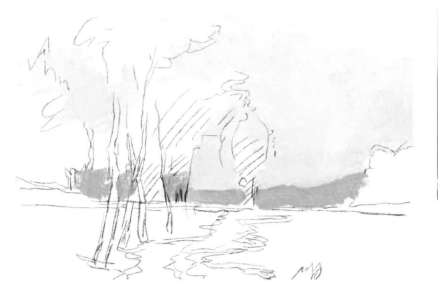
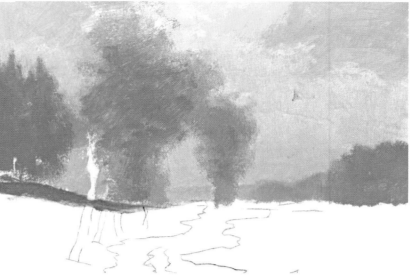
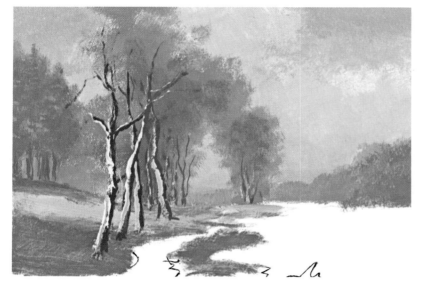
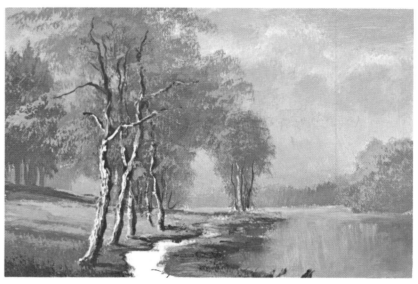
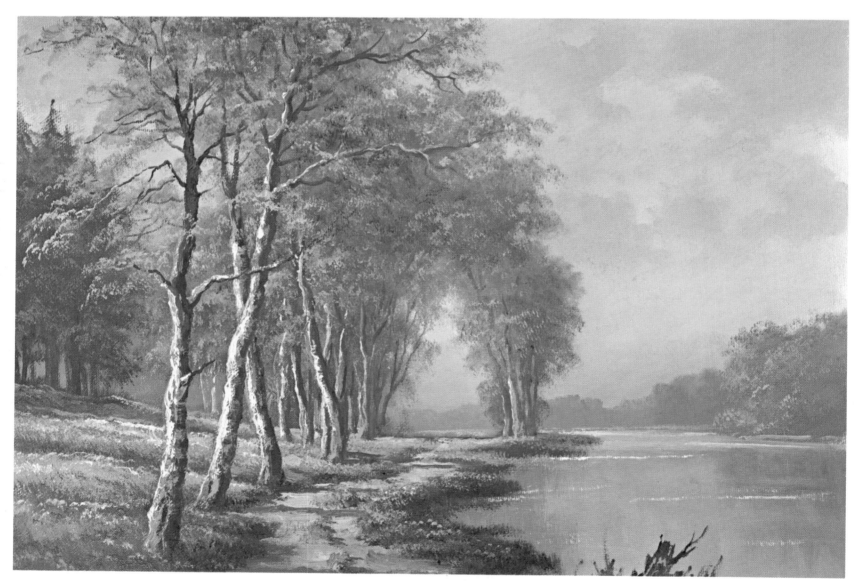

This path along a small lake invites you to take a walk. The steps above may help you. They show how to begin with the lighter colors (sky and background), and then come nearer to the foreground with the deeper colors. After some practice, everyone will find his own way to start a painting.

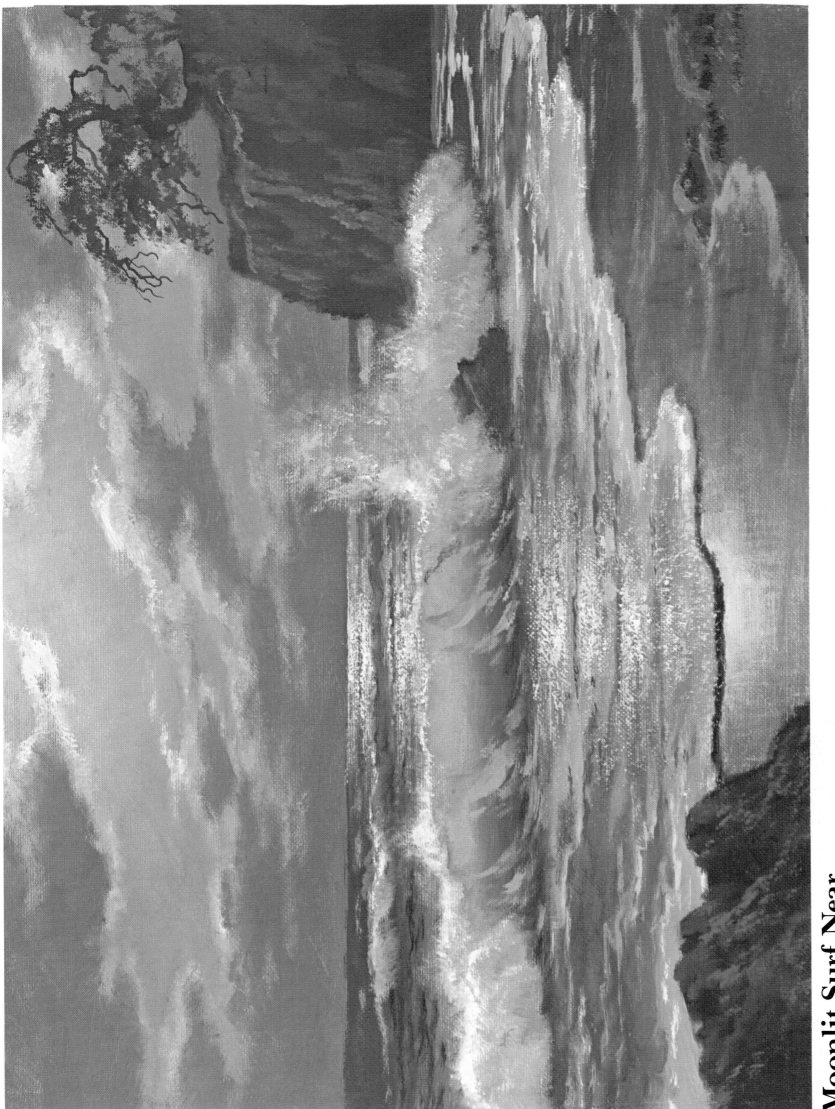

Moonlit Surf Near Monterey, California

In the dark of the night the reflection of the moon on the water makes a wonderful sparkling effect. Use Paris Blue for mixing the dark colors of the sky and water.

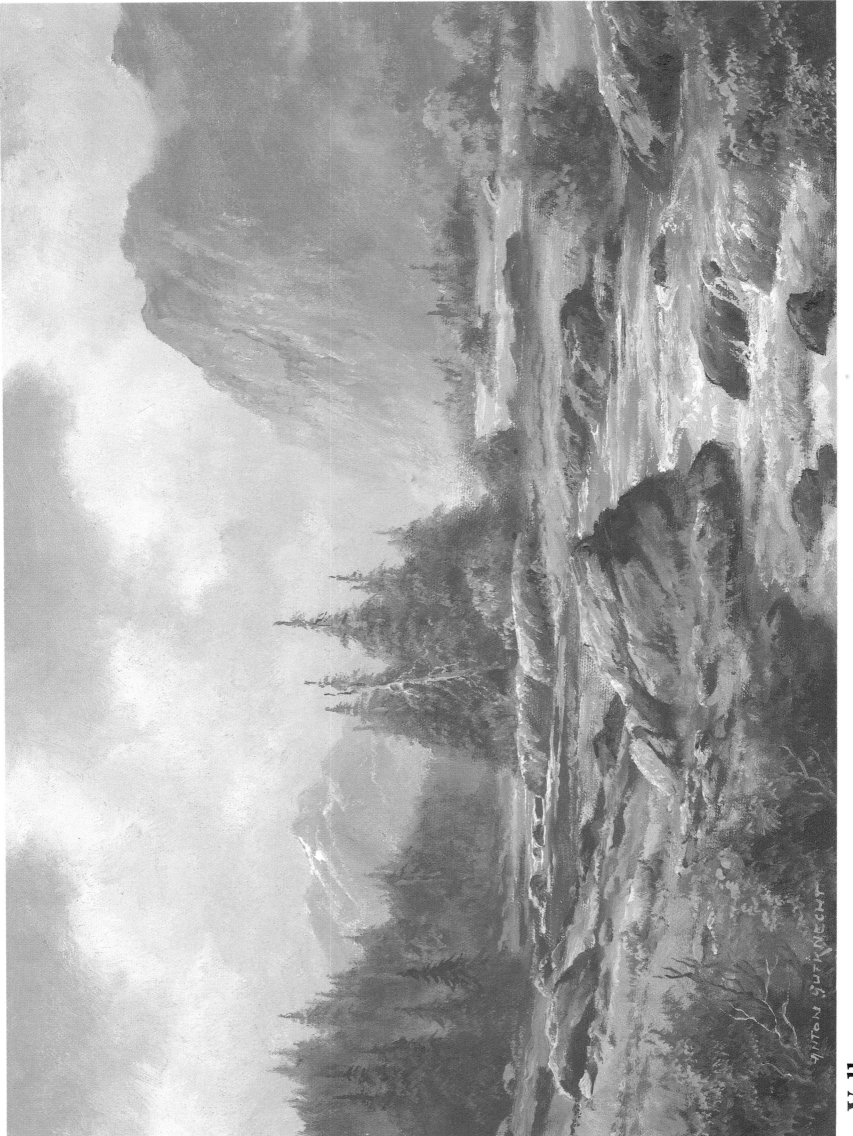

Valley Stream

The mountains in the background should be painted with soft colors, but use deep colors for the foreground.

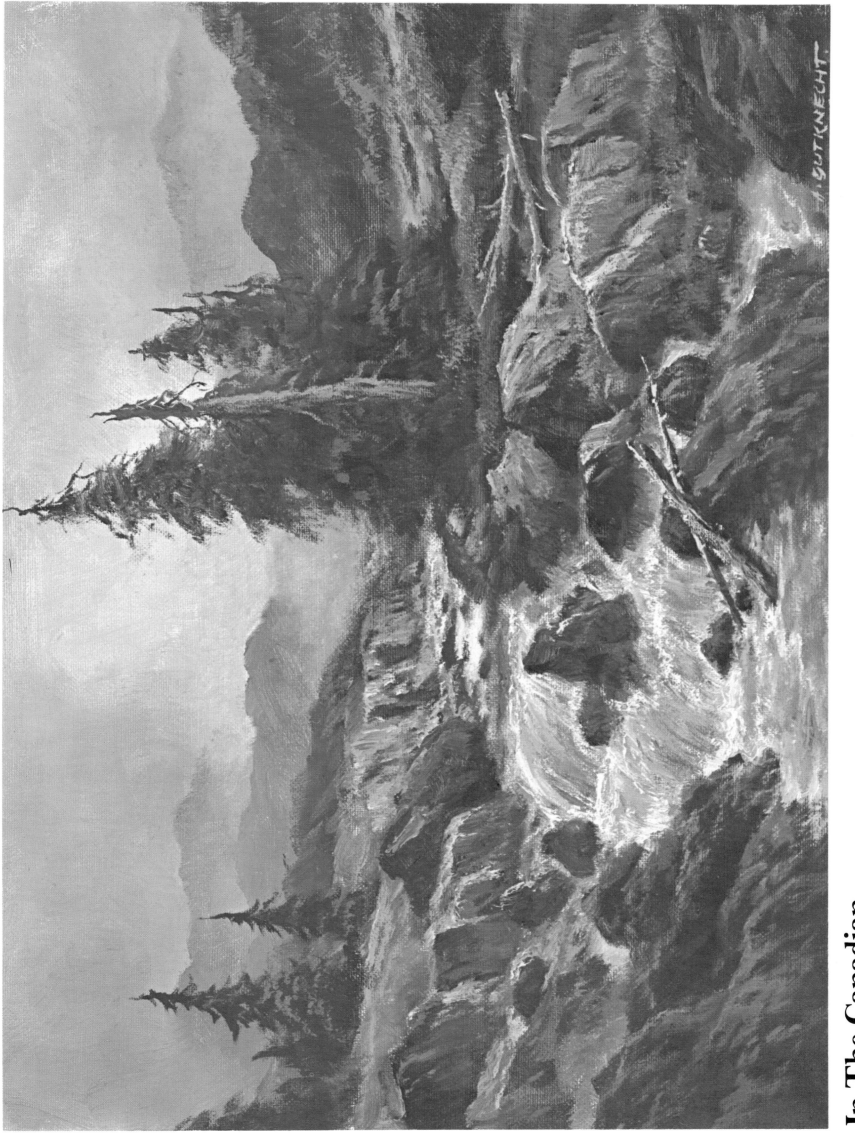

In The Canadian Rocky Mountains

The wild, fierce waters of this stream force their way through the rocks. The low clouds add to the romantic mood of this wilderness.

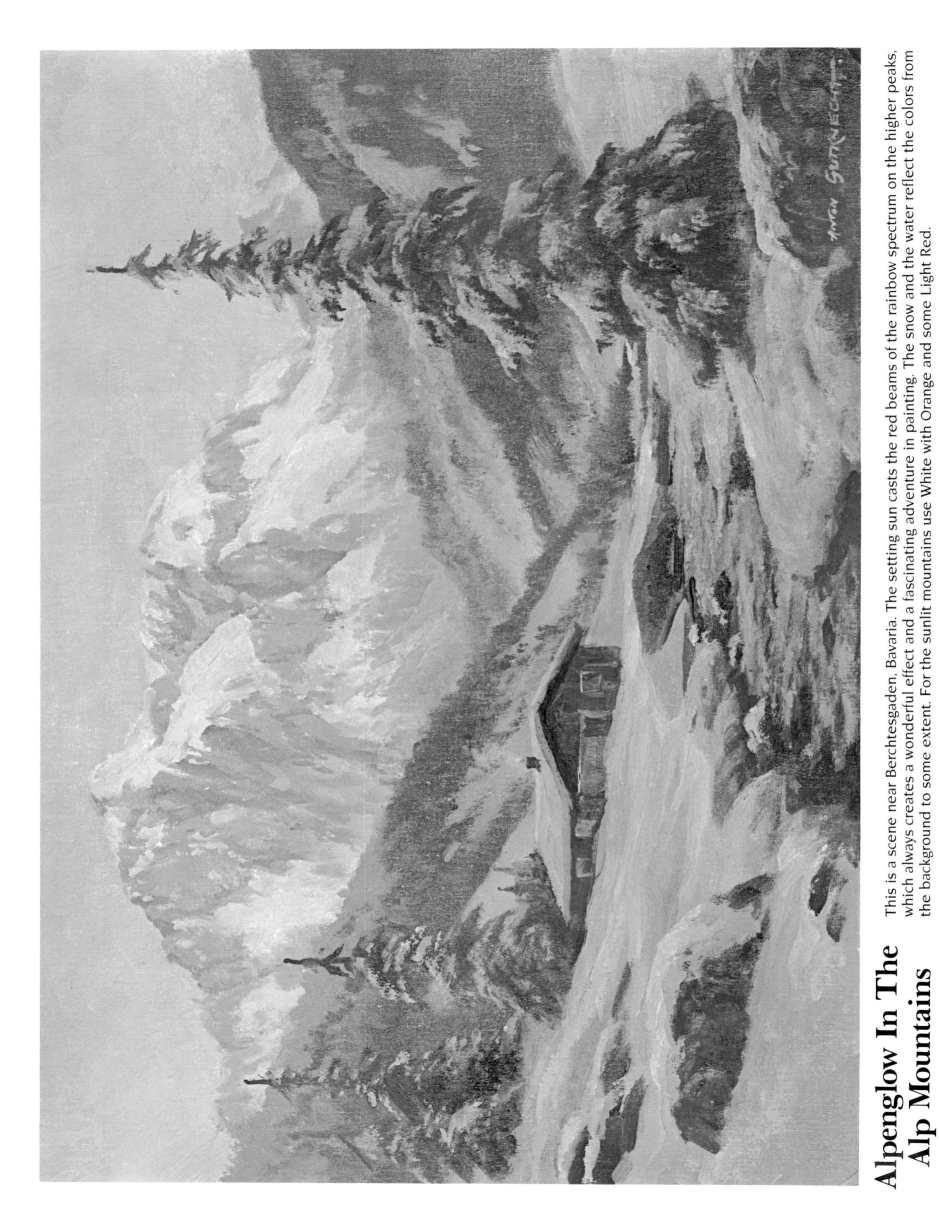

Alpenglow In The Alp Mountains

This is a scene near Berchtesgaden, Bavaria. The setting sun casts the red beams of the rainbow spectrum on the higher peaks, which always creates a wonderful effect and a fascinating adventure in painting. The snow and the water reflect the colors from the background to some extent. For the sunlit mountains use White with Orange and some Light Red.

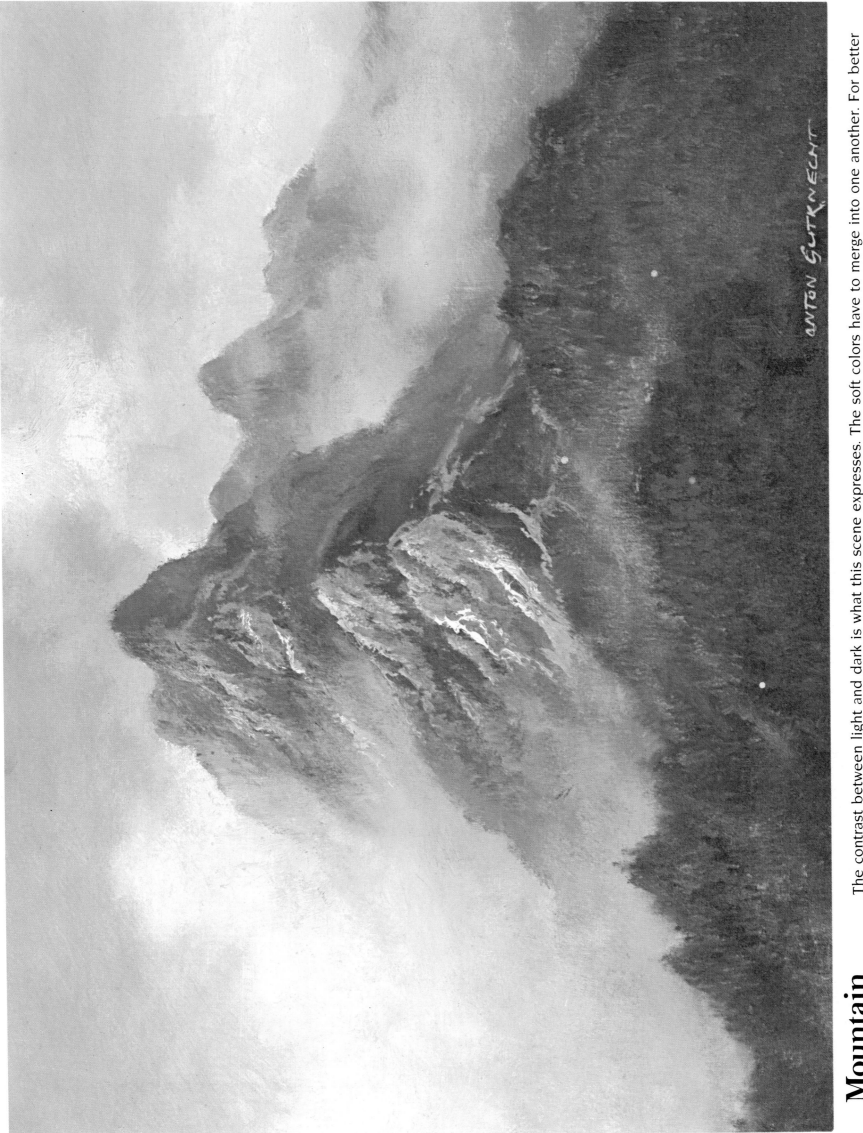

Mountain Mist

The contrast between light and dark is what this scene expresses. The soft colors have to merge into one another. For better blending of shades, clean brush with a piece of paper (always handy) and with soft strokes, carefully clear away the difference from one color to the other.

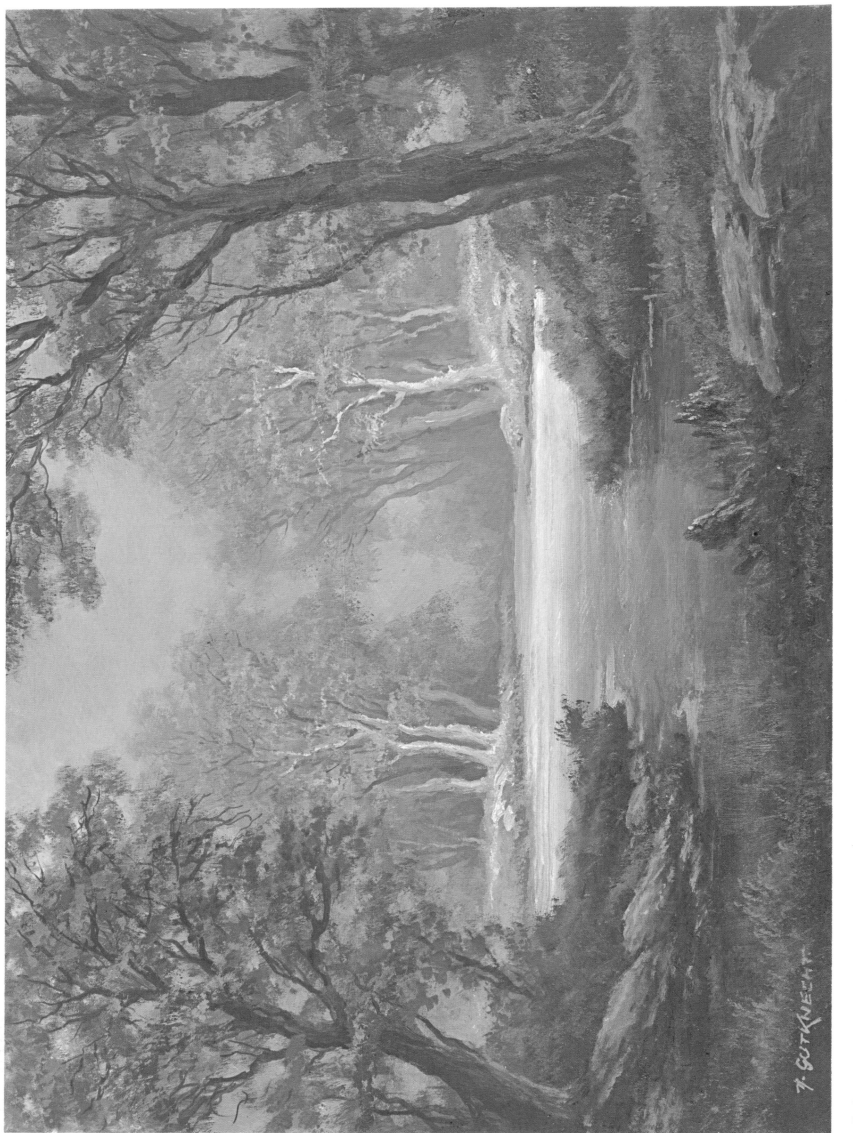

Gloomy Day

This painting shows light and dark combined to make a good contrast. The sun breaks through the foggy sky and brightens the middle part while the foreground stays in dark shadow.

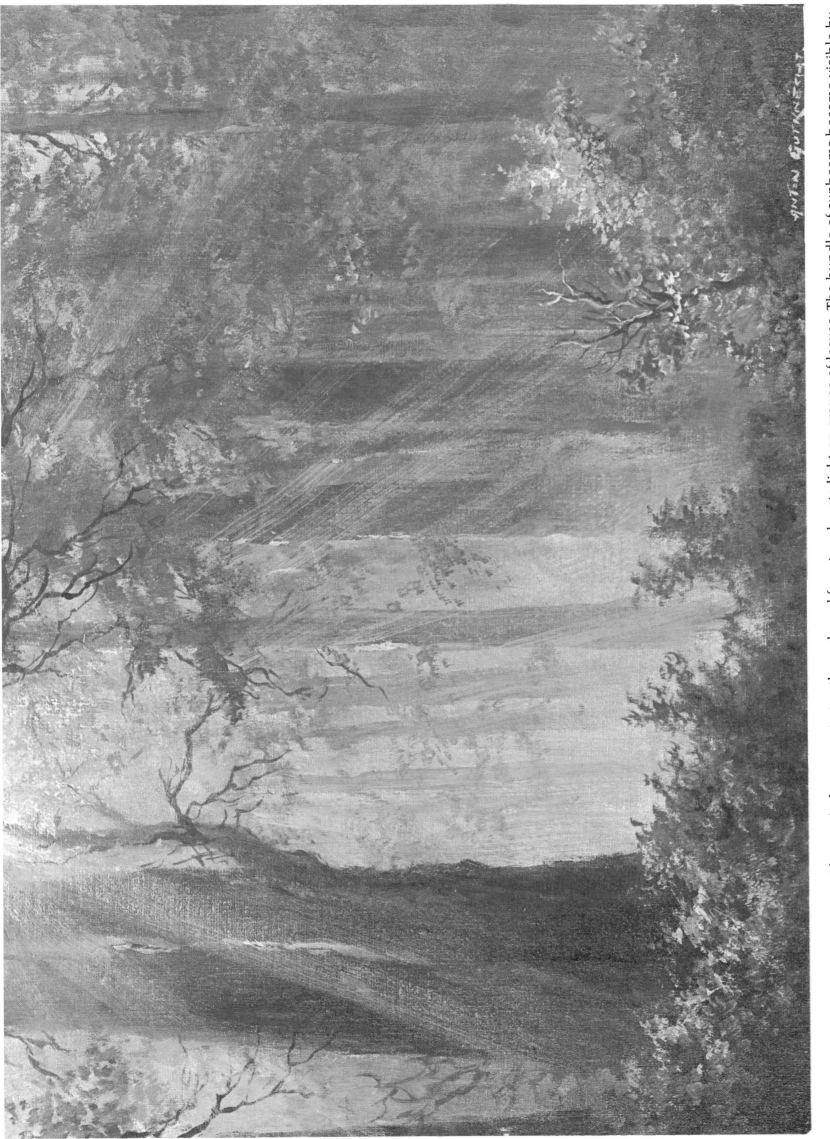

Painting
The Sunbeams

The sun in front penetrates the redwood forest and casts light on groups of leaves. The bundle of sunbeams become visible by the moist air they hit, a wonderful effect. To give the last touch to the sunbeams you must first let the painting dry. Only if it is quite dry can you find the beams by wiping a very little color smoothly over them in the direction from the sun. If you get too much, wipe it off (not totally) with a piece of cloth.

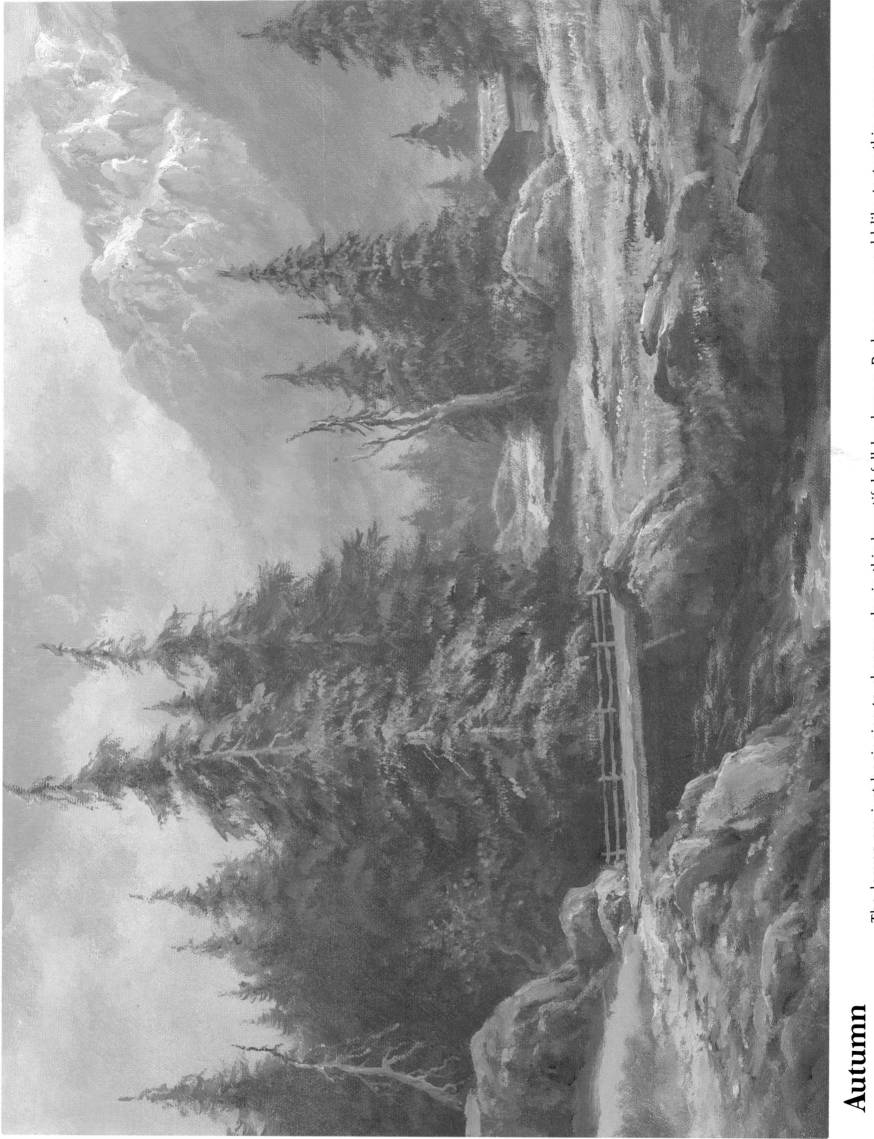

Autumn Retreat

The leaves are just beginning to change color in this beautiful fall landscape. Perhaps you would like to try this scene on your own.

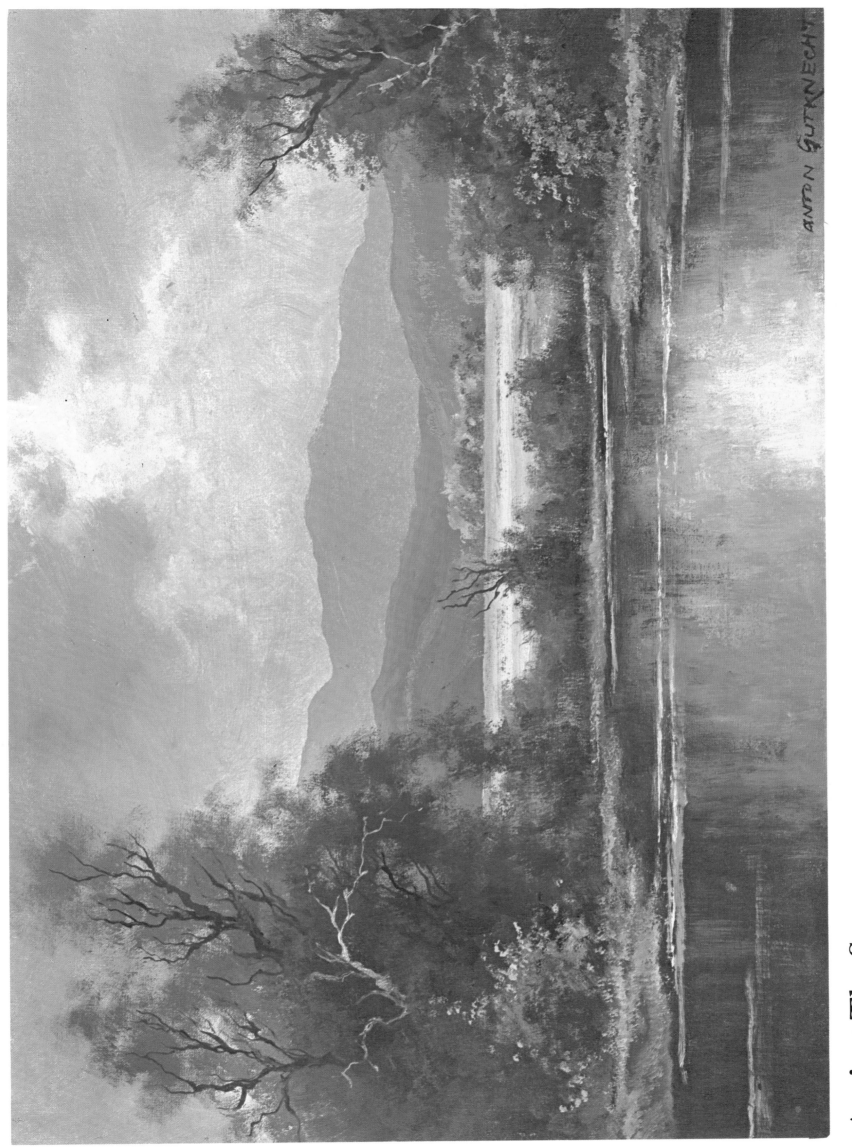

Against The Sun

This painting is somewhat impressionistic, insofar as to mainly show the colors. Leave the details more indistinct.

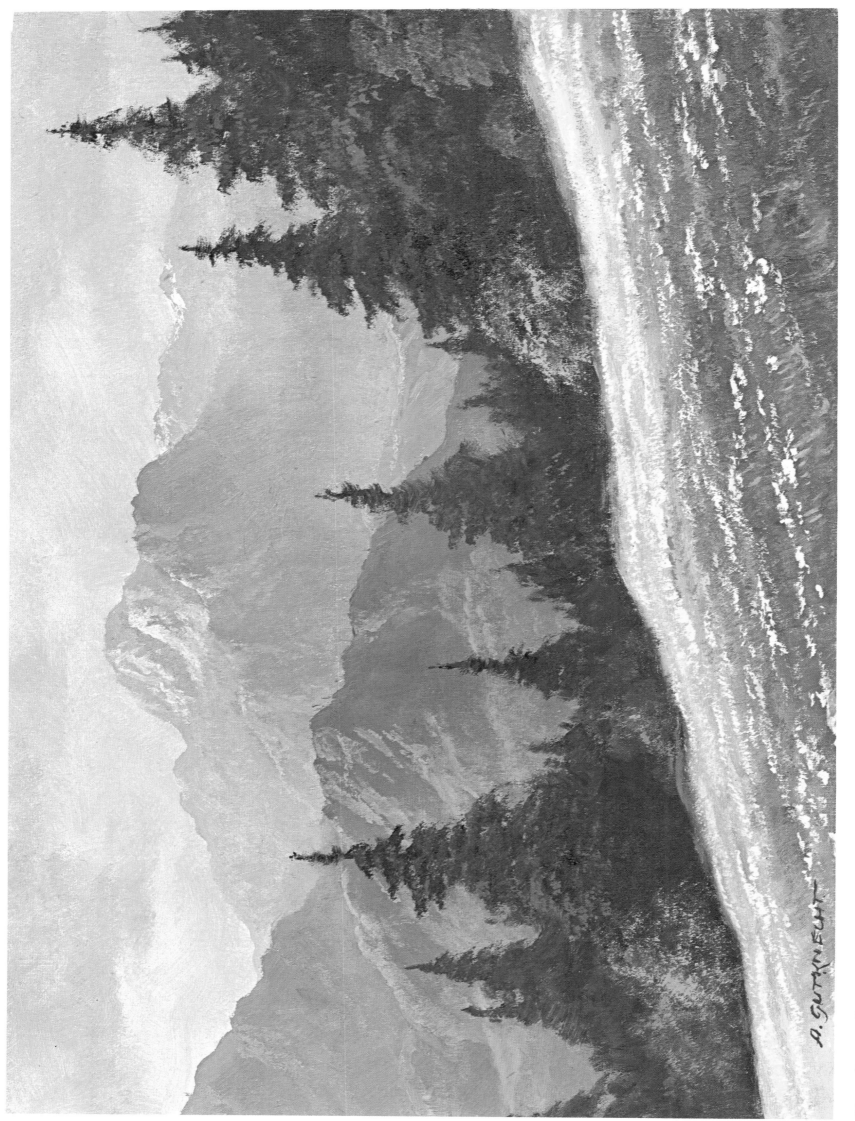

Springtime

This is a foggy morning with the sun dimly beginning to break through the fog. The trees stand dark against the bright atmospheric background.

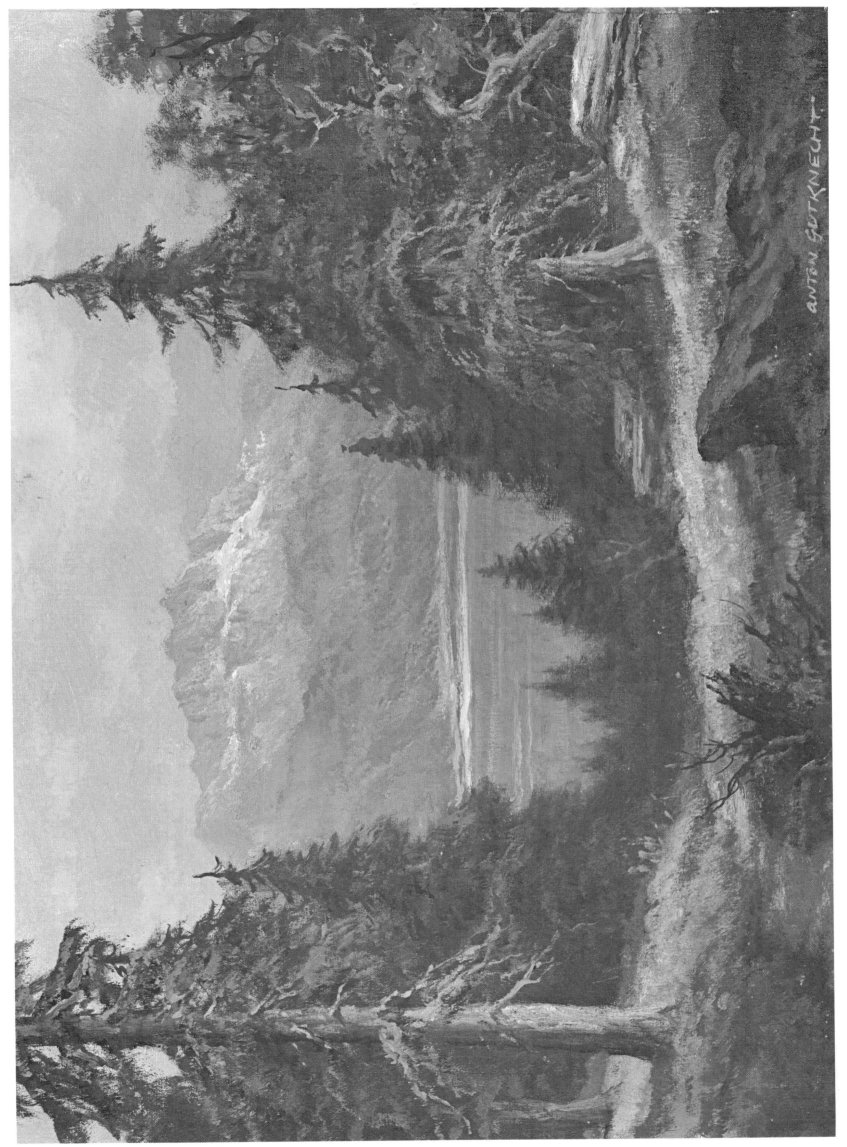

Lake In The Austrian Alps

This beautiful mountain scene is a good place for calm and rest as well as to paint.

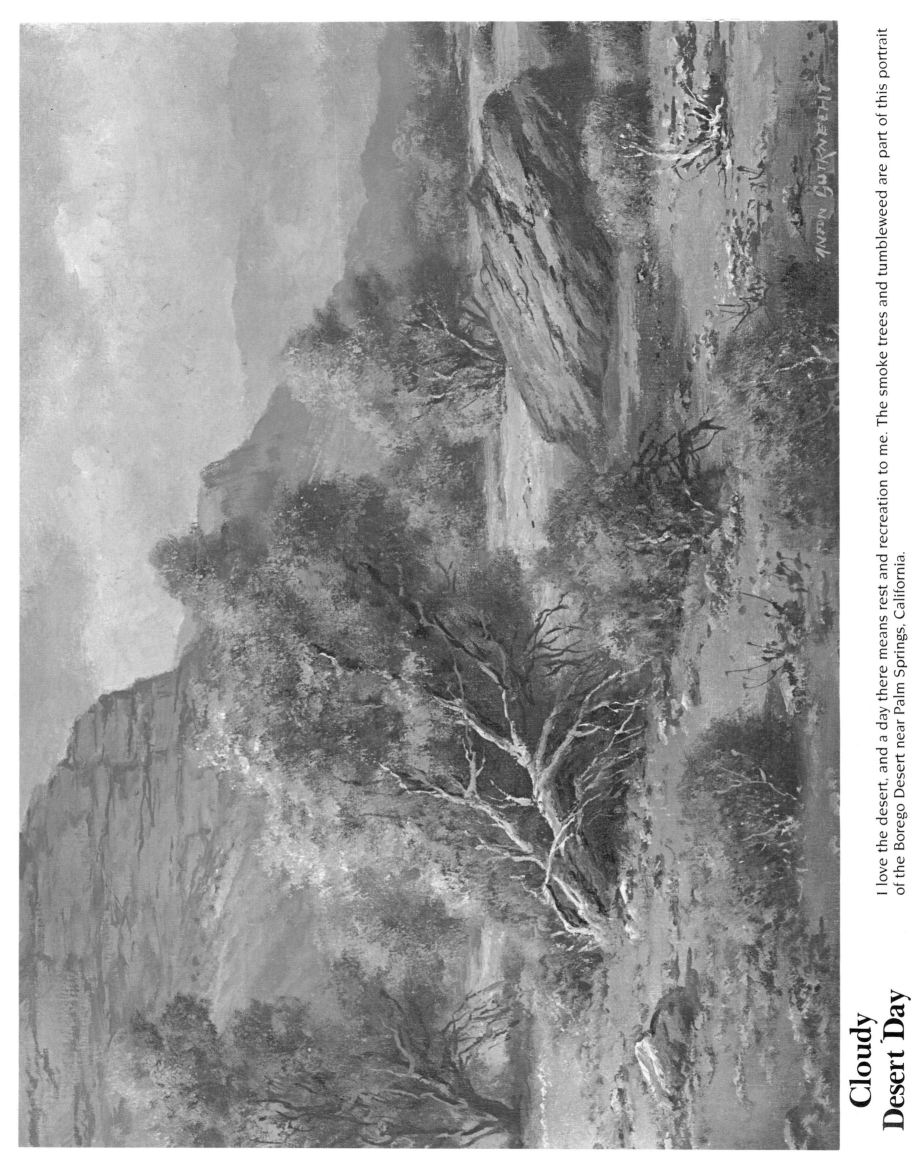

Cloudy
Desert Day

I love the desert, and a day there means rest and recreation to me. The smoke trees and tumbleweed are part of this portrait of the Borego Desert near Palm Springs, California.

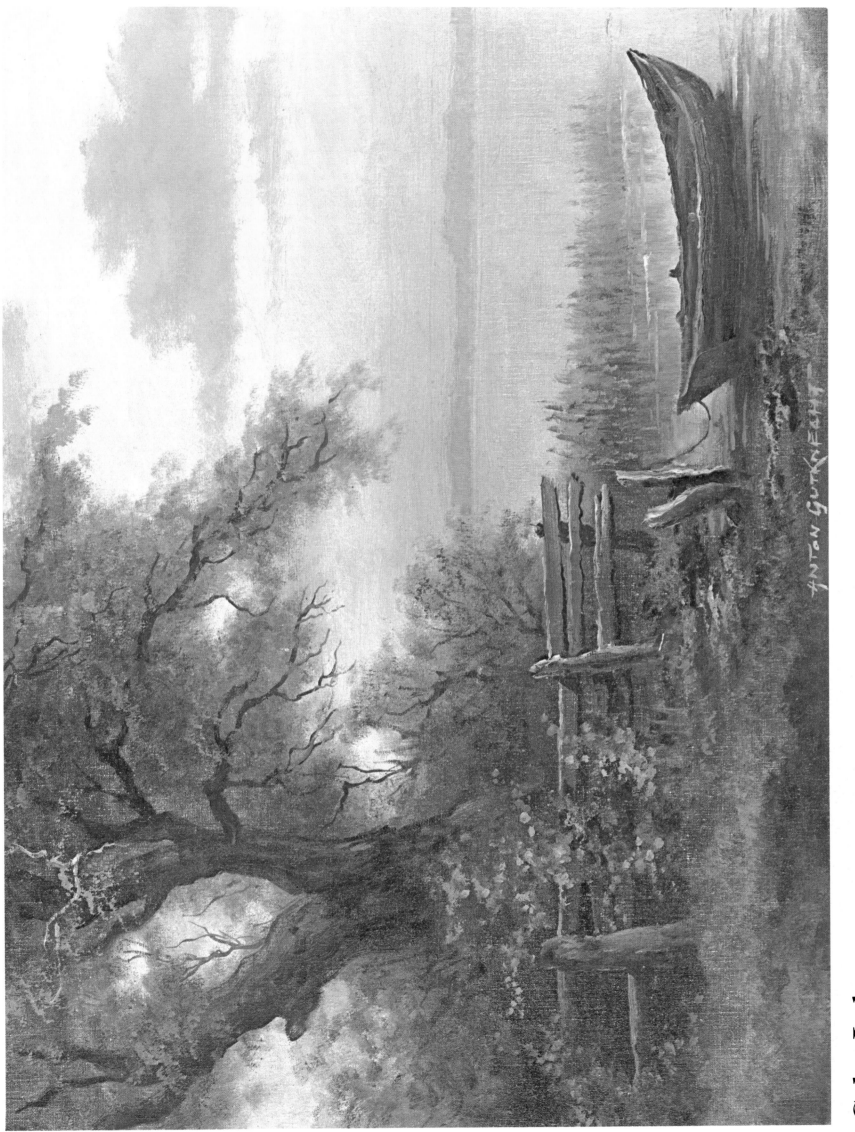

Calm Lake

The rowboat seems to be resting in this cove, waiting for its owner to pick up the oars. In the distance are the hills; the view scarcely reaches the other shore.

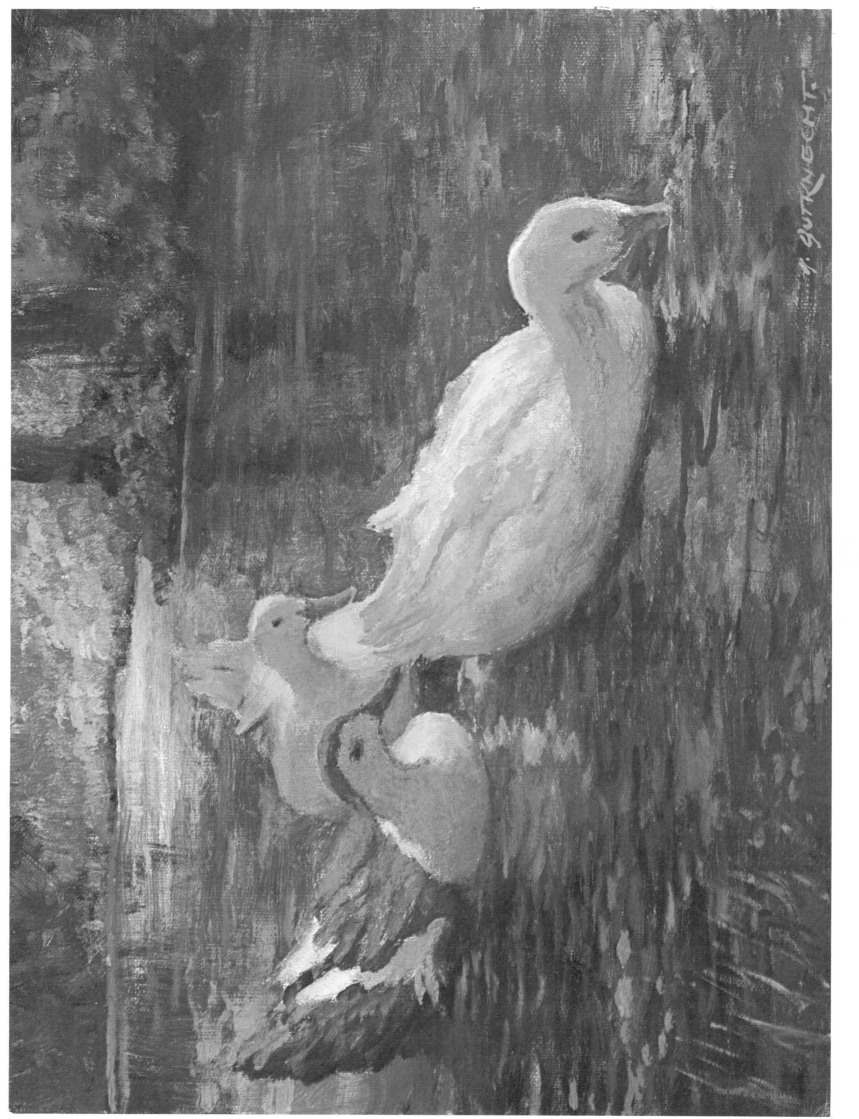

Family Of Ducks

Notice how the surrounding trees are reflected in the water. The ducks make an interesting contrast to the dark colors.

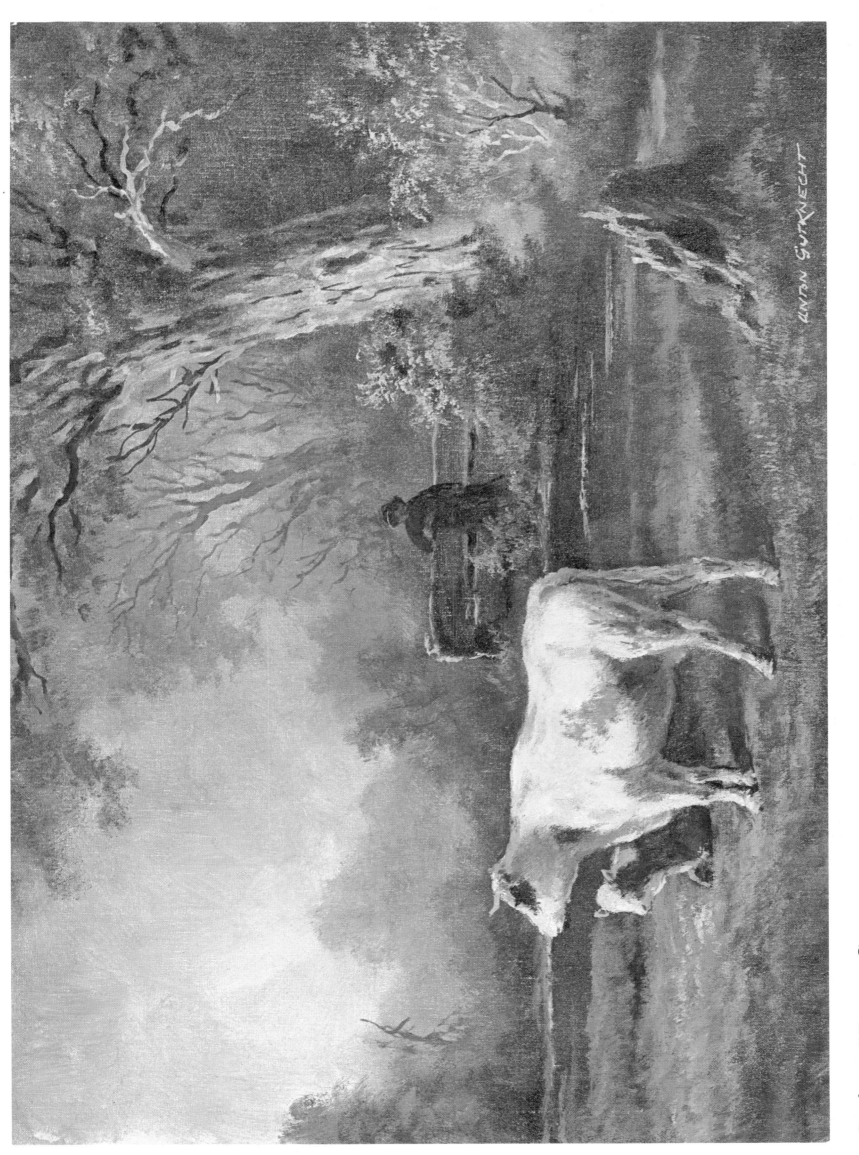

Going Home Soon

There are Walter Foster books by famous artists for painting specific animals and other subjects (see list on the last page).